Off The Leash

DOGGY DOODLES

A DOODLE SKETCHBOOK FOR DOG-LOVERS

F

FRANCES
LINCOLN

Frances Lincoln Limited
www.franceslincoln.com

Off The Leash Doggy Doodles
Copyright © Frances Lincoln Limited 2016
Illustrations copyright © Rupert Fawcett 2016
Off The Leash copyright © Rupert Fawcett 2016
Licensed by Clive Juster & Associates

First Frances Lincoln edition 2016

A catalogue record for this book is available
from the British Library

ISBN 978-0-7112-3798-8
Printed in China

9 8 7 6 5 4 3 2 1

Quarto is the authority on a wide range of topics.

Quarto educates, entertains and enriches the lives of
our readers – enthusiasts and lovers of hands-on living.

www.QuartoKnows.com

Off The Leash
DOGGY
DOODLES

A DOODLE SKETCHBOOK FOR DOG-LOVERS

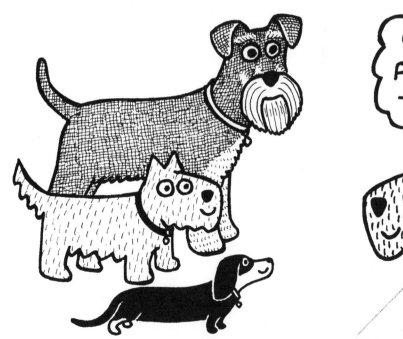

CAN I HAVE A BIG FLUFFY TAIL PLEASE?

Rupert Fawcett

RF

the WONDERFUL

THING ABOUT DOGS IS THEY
COME IN SO MANY DIFFERENT
SHAPES AND SIZES...

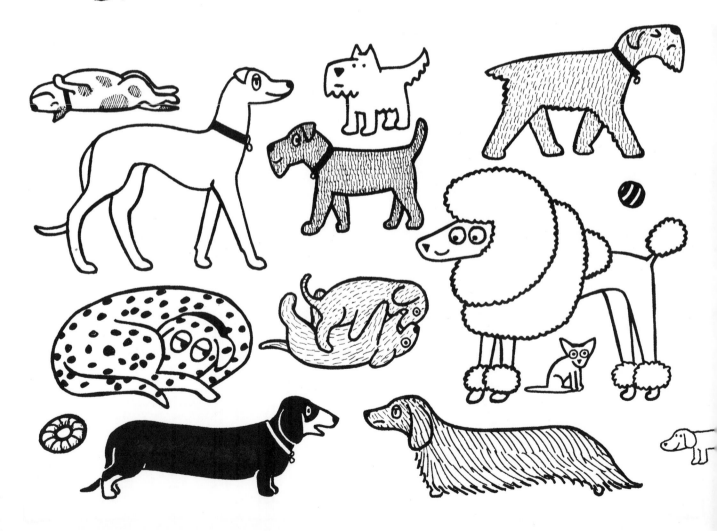

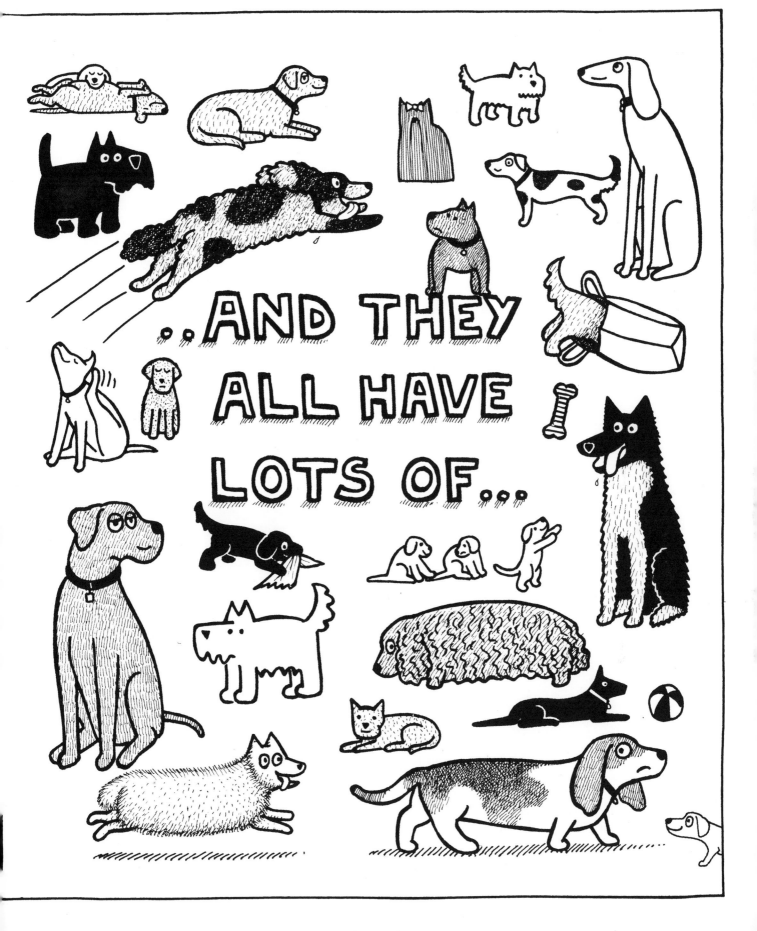

...AND THEY ALL HAVE LOTS OF...

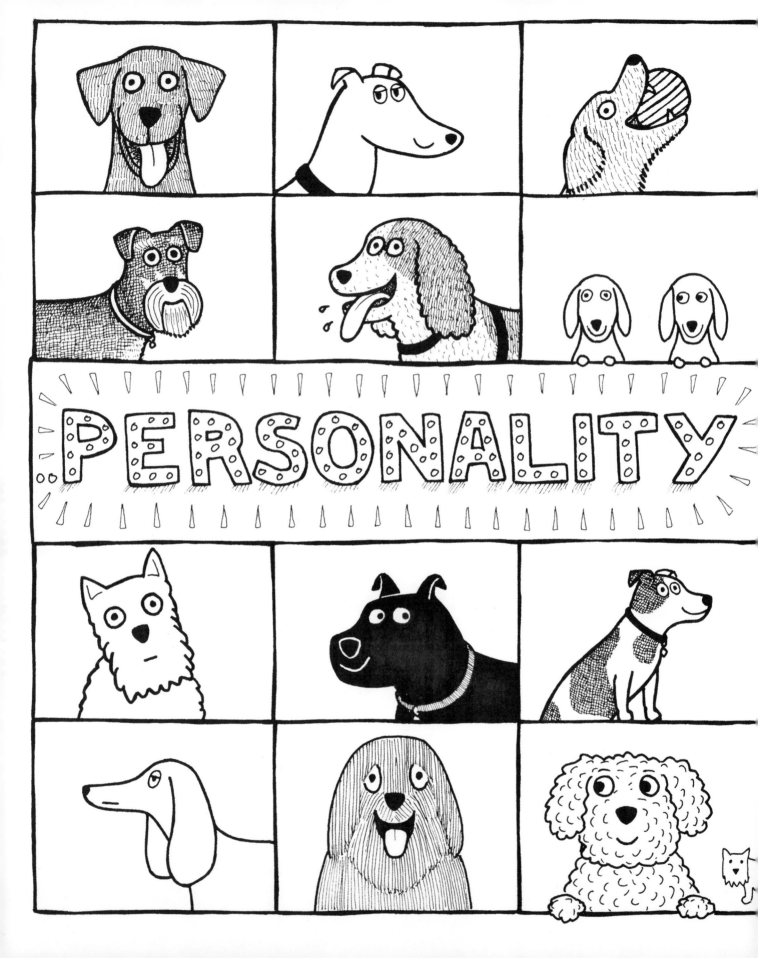

DRAWING DOGS

 THERE ARE MANY DIFFERENT WAYS TO DRAW A DOG AND IT'S IMPORTANT YOU FIND THE WAY THAT SUITS YOU BEST.

I DRAW DOGS EVERY DAY AND HAVE DEVELOPED MY OWN PARTICULAR TRICKS AND TECHNIQUES. PERHAPS YOU CAN TRY SOME OF THEM!

HOW TO DRAW A DOG

Think about what type of dog you would like to draw!

A **BIG** DOG...

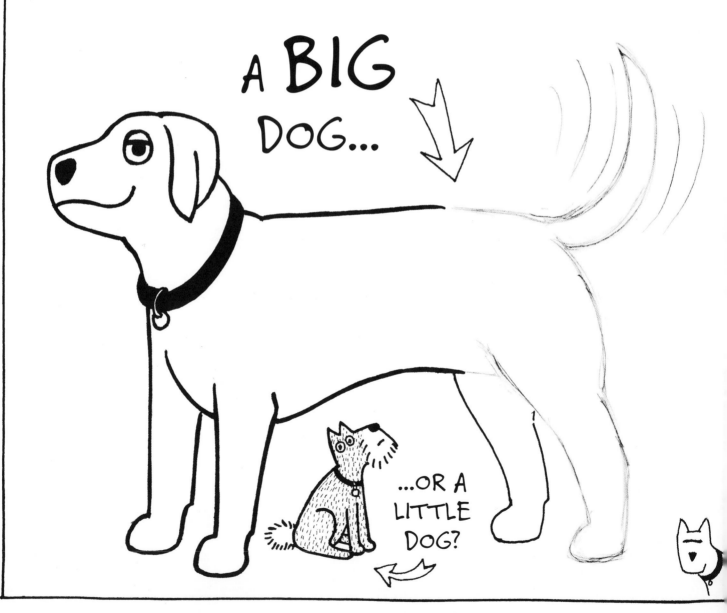

...OR A LITTLE DOG?

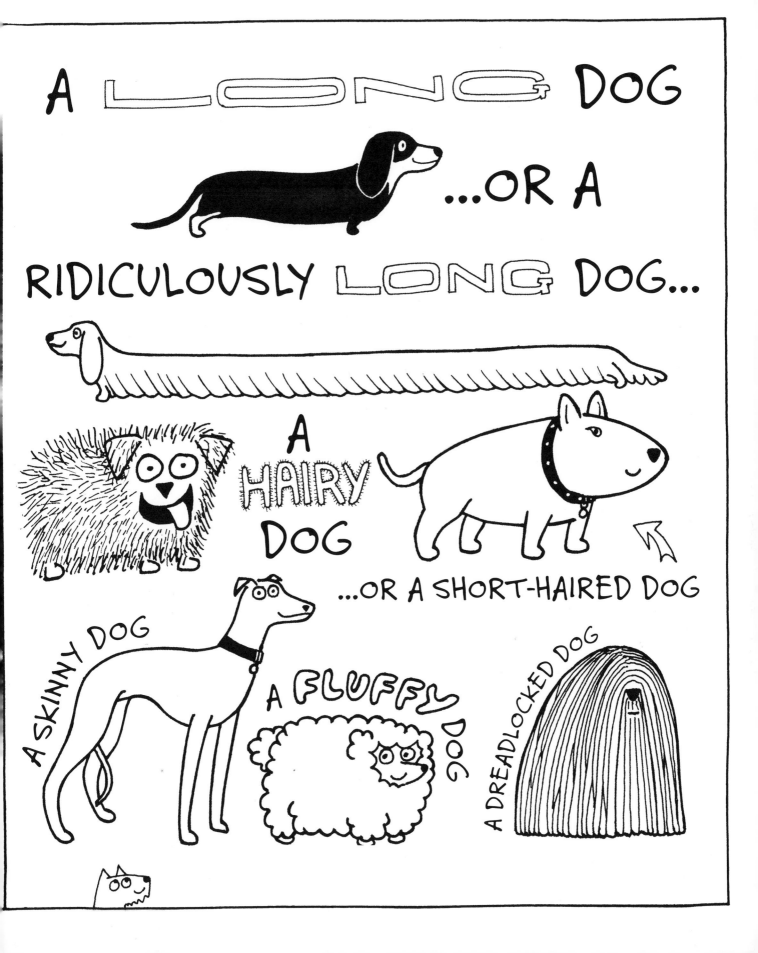

GETTING STARTED...

① START your drawing with some very SIMPLE, basic lines.

② ADD more body, thinking about the positions of the PAWS, TAIL, HEAD and EARS.

3

Continue to BUILD stronger, more defined lines, erasing OLD ONES as you progress.

4

ADD facial features. The eyes and mouth are IMPORTANT as they express the MOOD of your DOG.

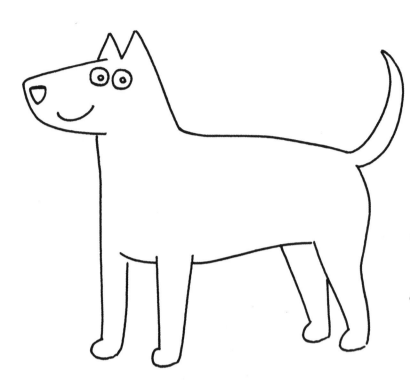

I would then draw over the PENCIL lines with an ink pen and <u>RUB OUT</u> the pencil work.

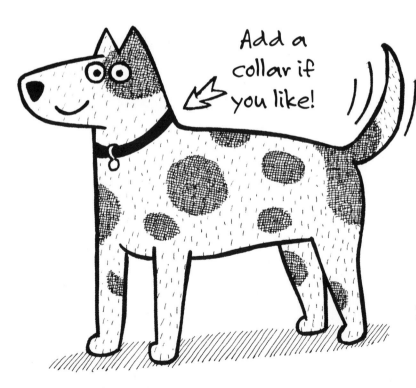

Add a collar if you like!

⑥

I use the PEN to go over the lines a second time, then add FUR and a shadow for a more 3D effect.

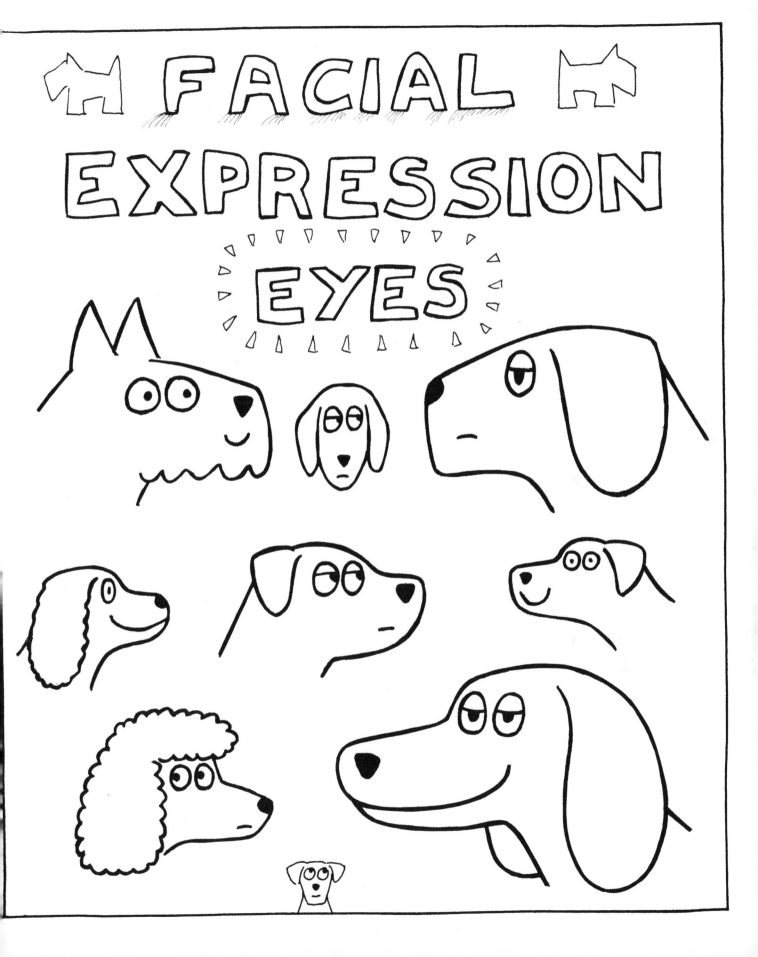

 EYES ARE THE MOST EXPRESSIVE PART OF A PORTRAIT. HAVE FUN FILLING IN THE EYES ON THESE EYELESS DOGS !

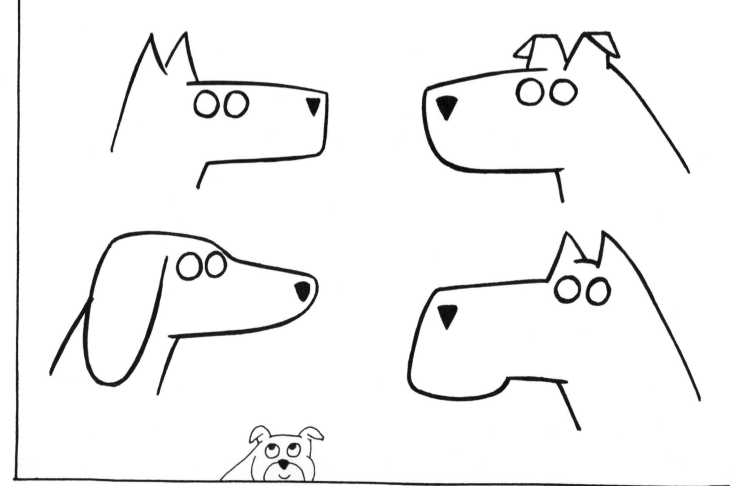

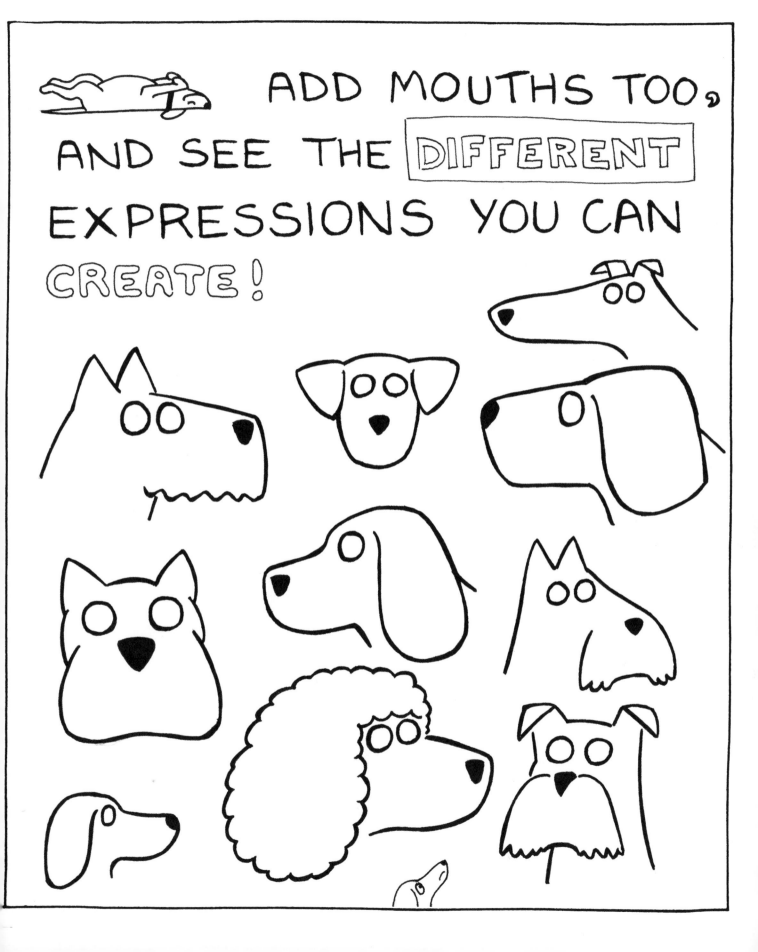

ADD MOUTHS TOO, AND SEE THE DIFFERENT EXPRESSIONS YOU CAN CREATE!

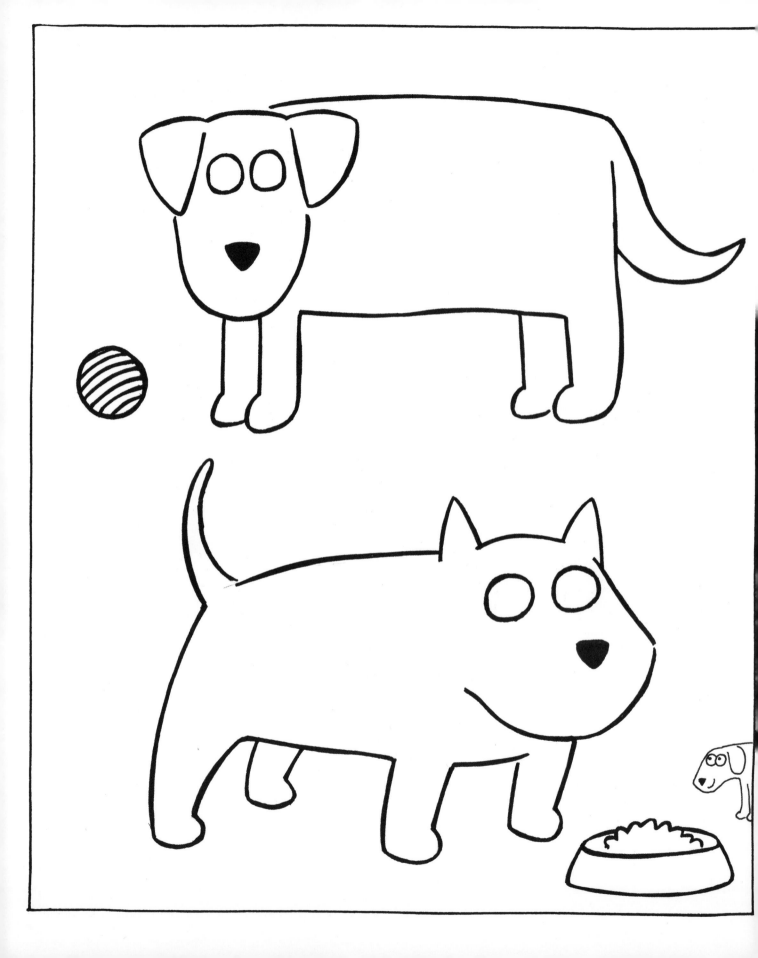

EYELASHES!

YOU CAN MAKE
YOUR DOGS FEMALE
BY SIMPLY ADDING
EYELASHES!

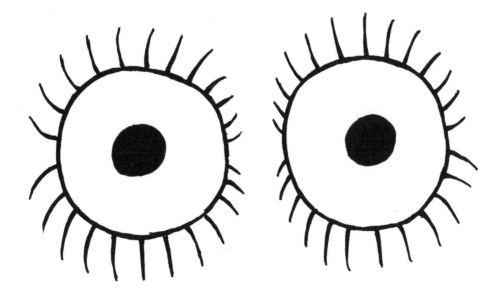

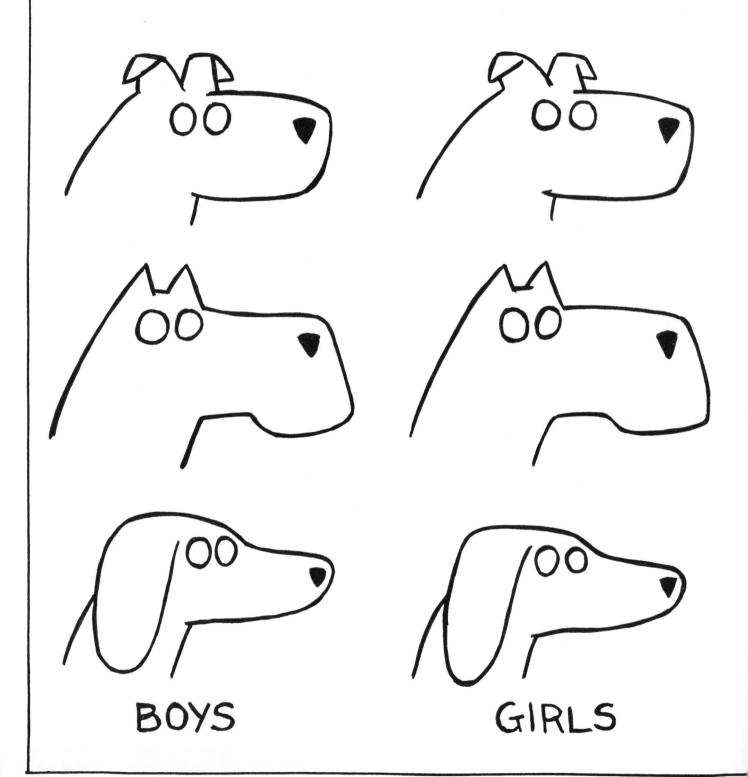

NOW create your own dogs
with EXPRESSIVE faces...

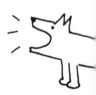

What is your dog thinking?
What is your dog FEELING?

WOOF WOOF!

Is it HAPPY, SAD, EXCITED, TIRED, TIMID, HUNGRY, FRIGHTENED?

You can use EYEBROWS too...

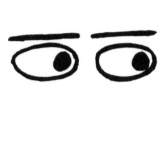
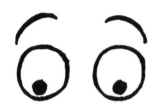
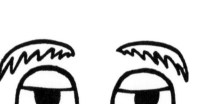
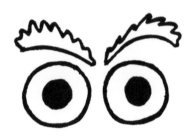
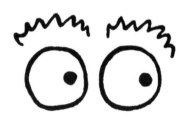

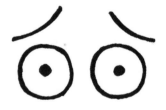

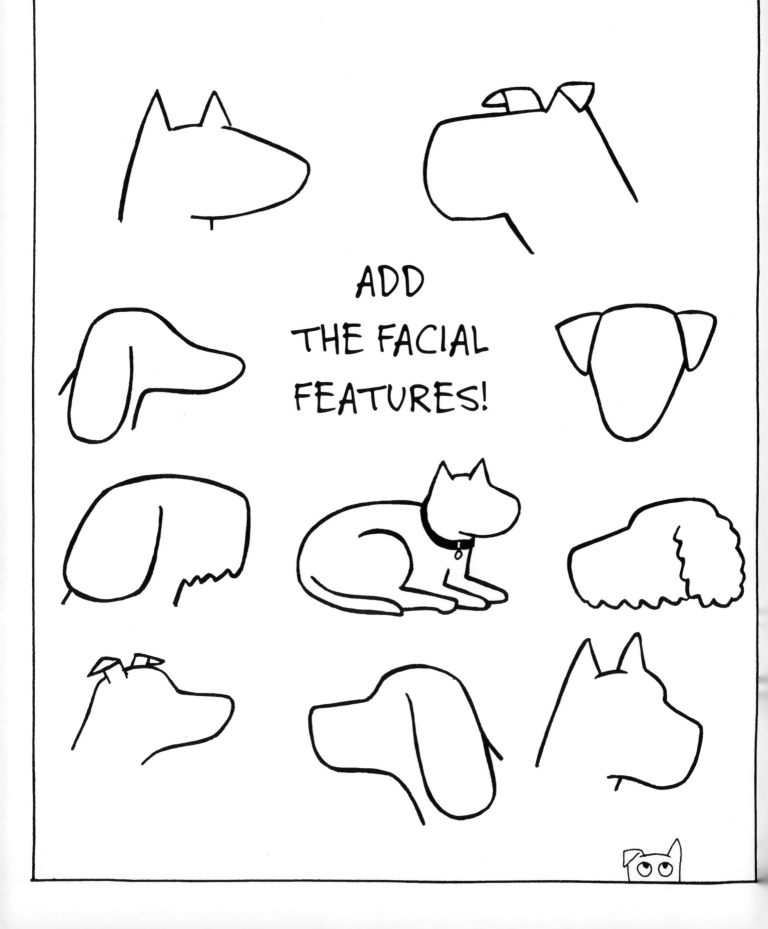

ADD
THE FACIAL
FEATURES!

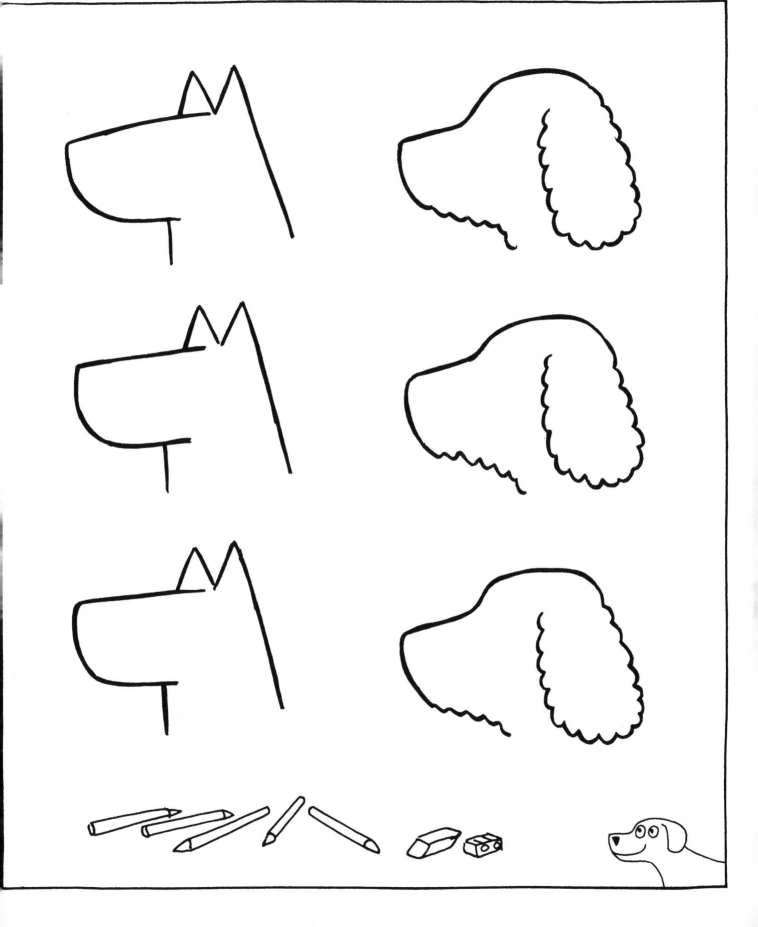

NOW add your own dogs to the FACIAL FEATURES!

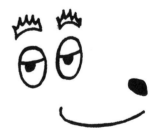
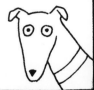

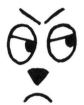
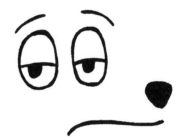

TAILS

An important part of your dog drawing is the tail...

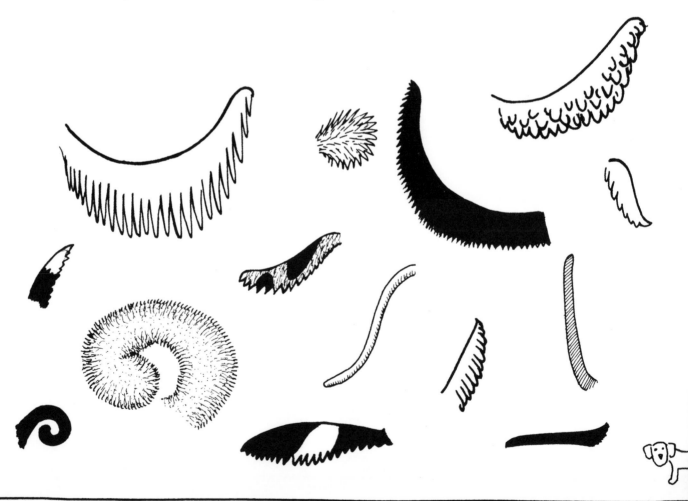

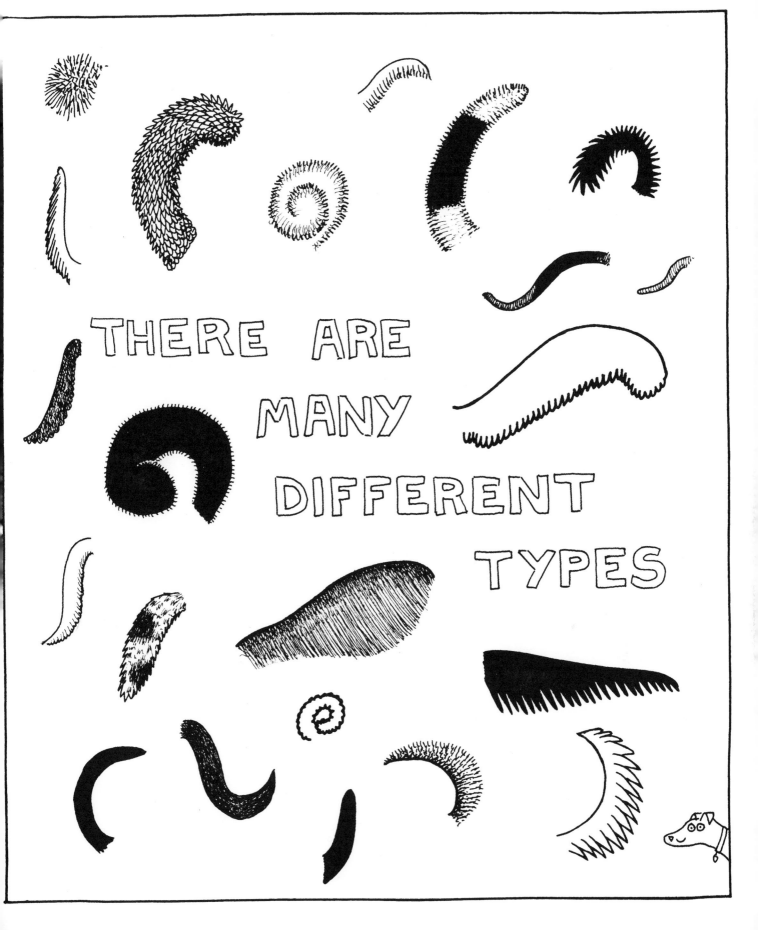

THERE ARE MANY DIFFERENT TYPES

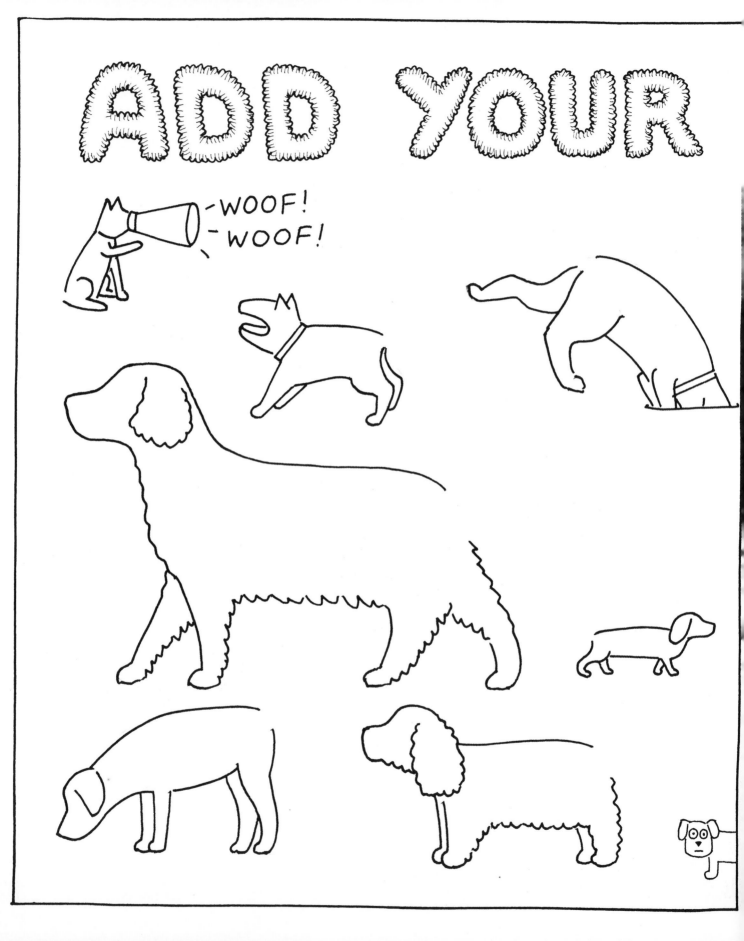

OWN TAILS
(and faces)

YAP!
YAP!

MORE...

AND MORE...

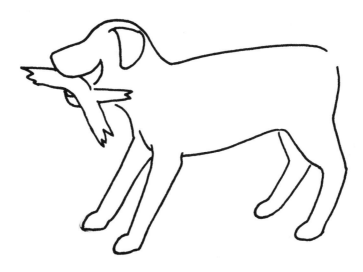

NOW ADD SOME DOGS...

TO THE
TAILS!

← A waggy one

Another
waggy one
↓

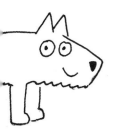

DOGGY DOODLES

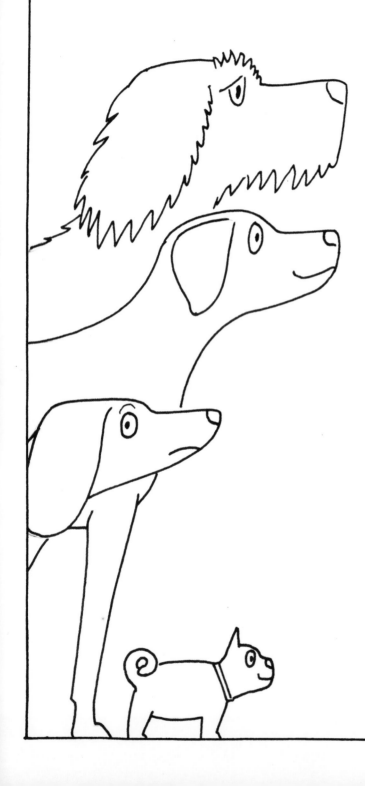

DOGGY DOODLES

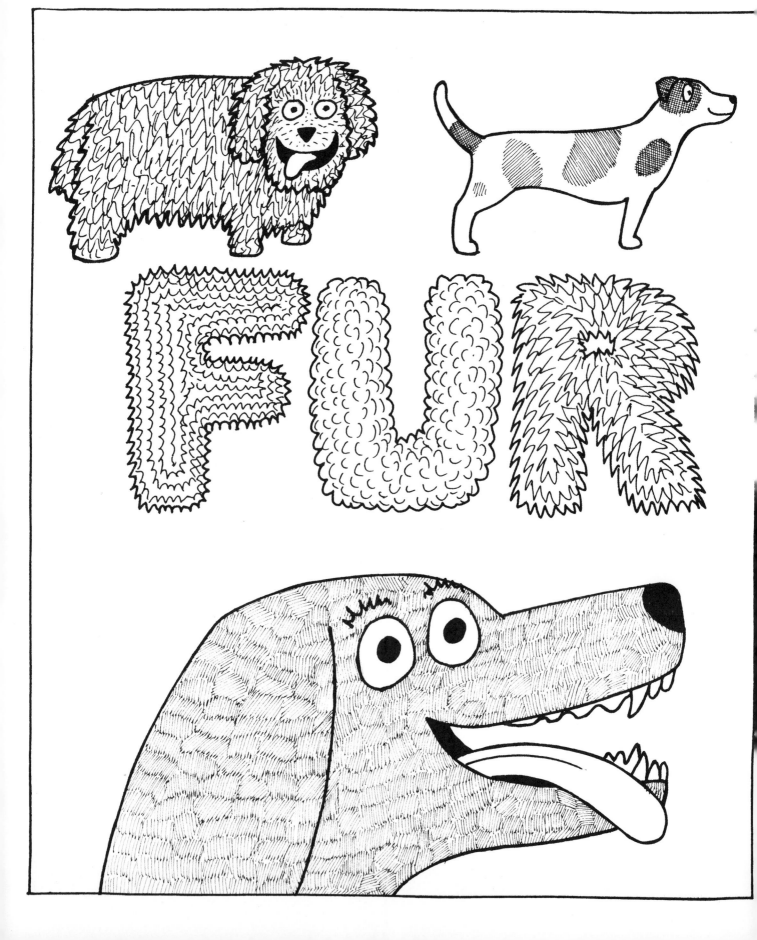

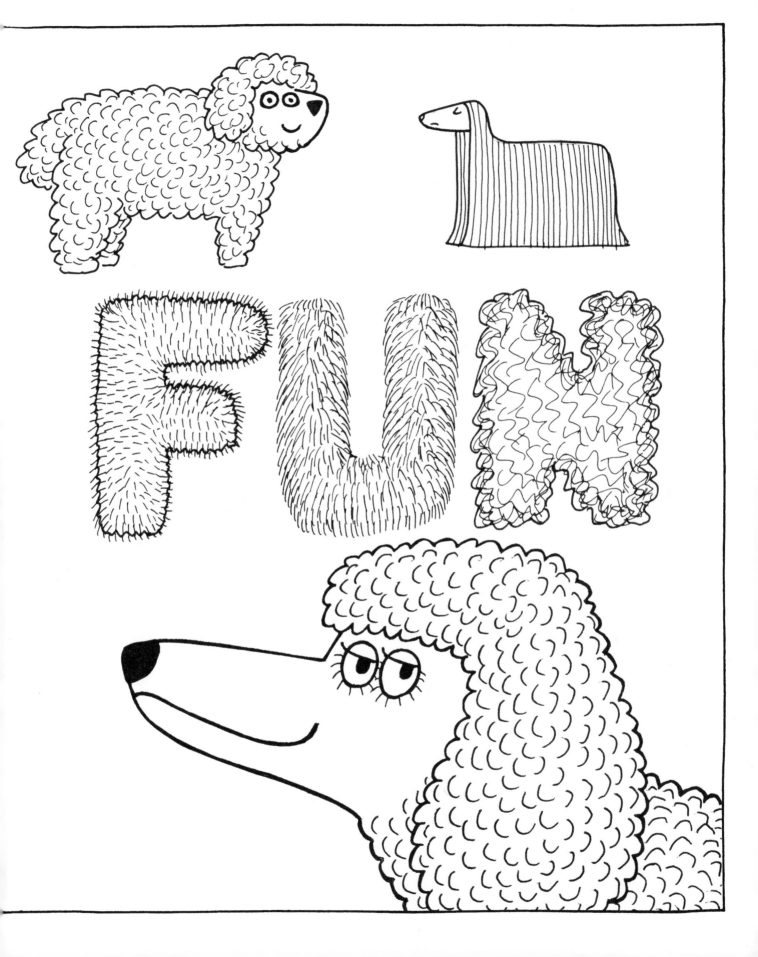

DOGS have many types of fur. Use your pencils and pens to EXPERIMENT with different effects...

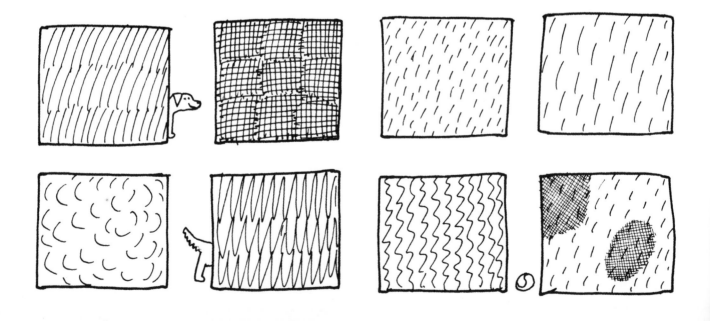

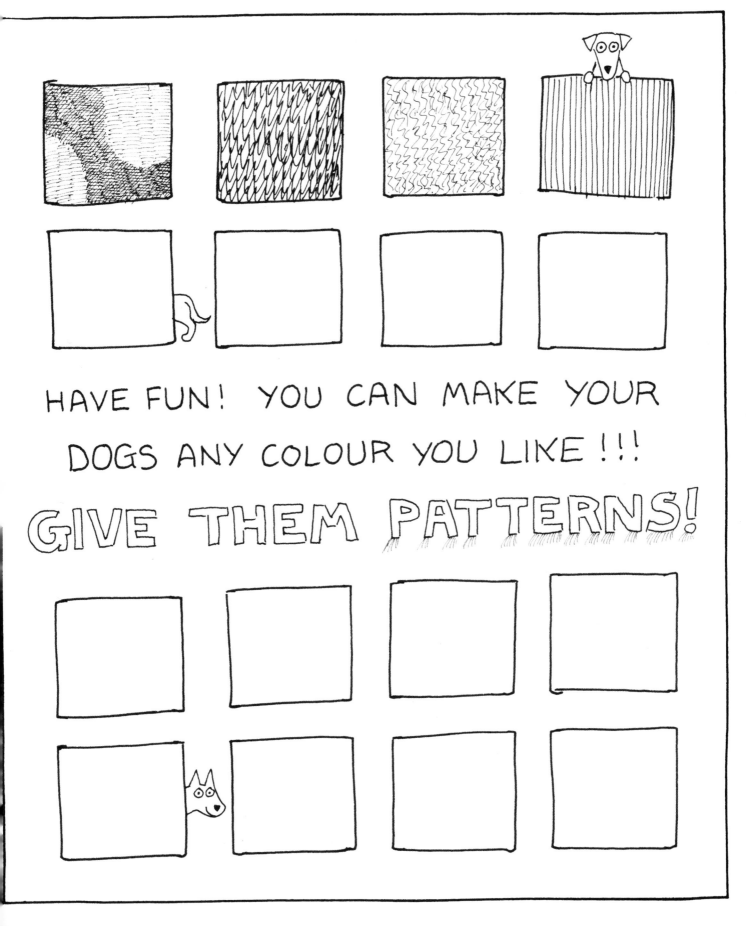

HAVE FUN! YOU CAN MAKE YOUR
DOGS ANY COLOUR YOU LIKE !!!

GIVE THEM PATTERNS!

EXPERIMENT...

EXPERIMENT...

OODLES of...

DOODLES...

DOODLES

poodles noodles

DOODLES...

THIS BOOK'S MESSIEST DOG

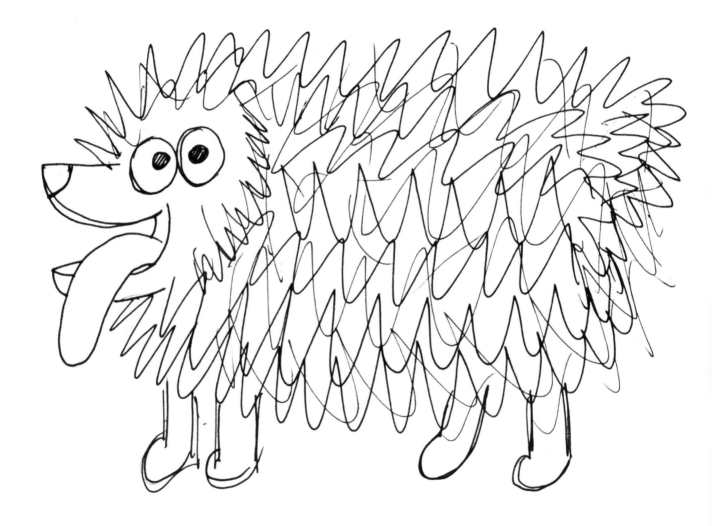

YOUR MESSIEST DOG

THIS BOOK'S THINNEST DOG

YOUR THINNEST DOG

THIS BOOK'S FATTEST DOG

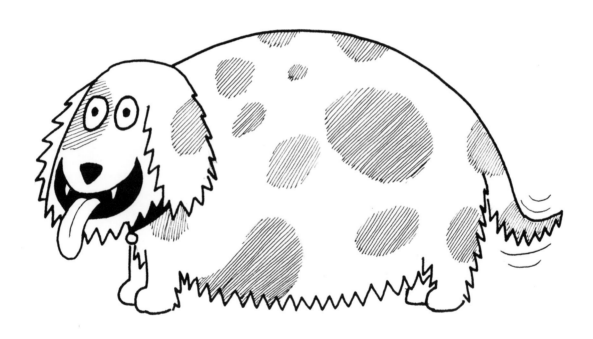

YOUR FATTEST DOG

ears

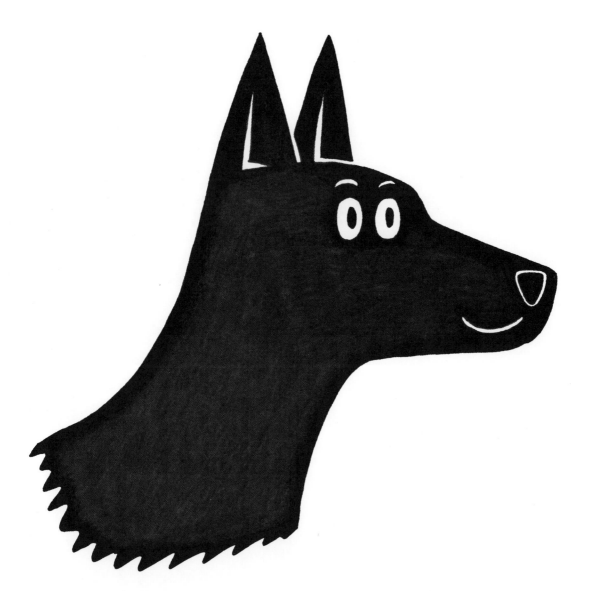

EARS add EXPRESSION and CHARACTER...

Have fun with EARS...

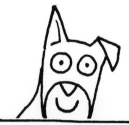

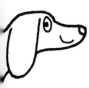

THESE DOGS NEED EARS...

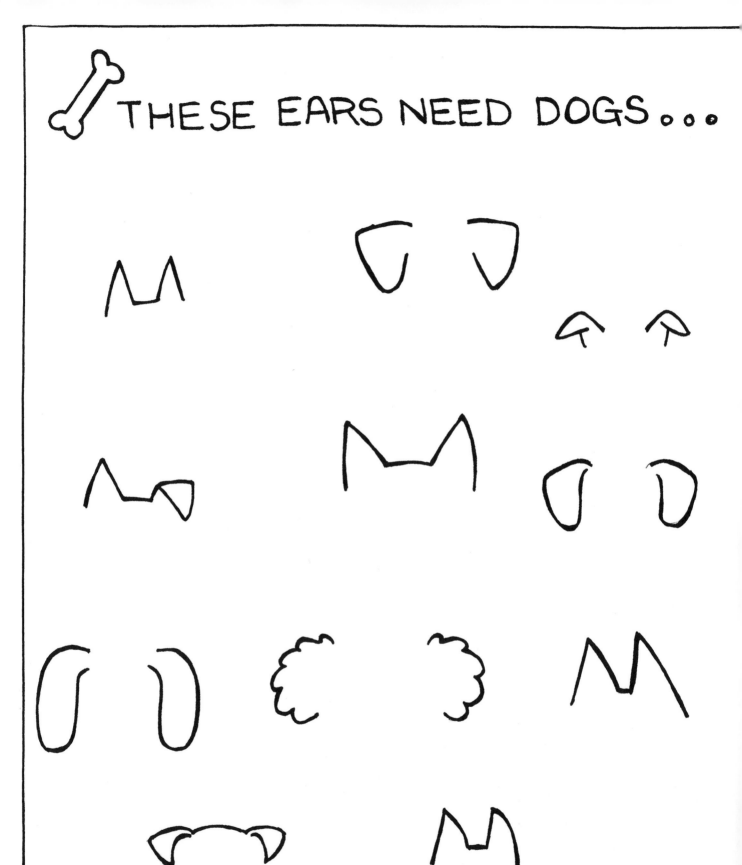

THESE EARS NEED DOGS...

DOODLES

DODDLES...

MOVEMENT

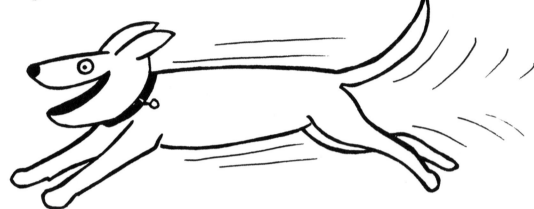

You can indicate movement with the simple addition of motion lines...

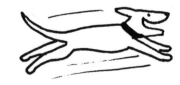

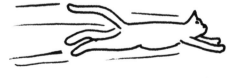

DOODLES

DOGGY BEHAVIOURS

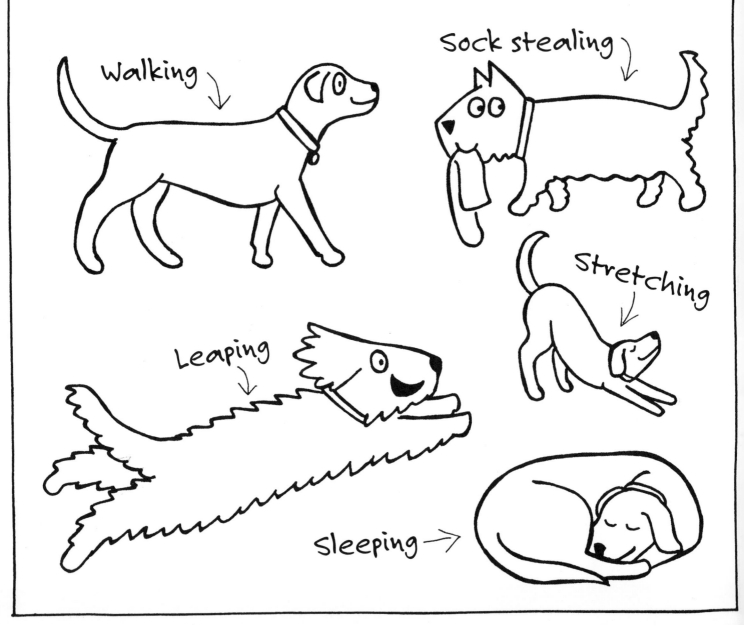

Walking →

Sock stealing ↘

Stretching ↓

Leaping ↓

Sleeping →

DOODLES

Doggy behaviours...

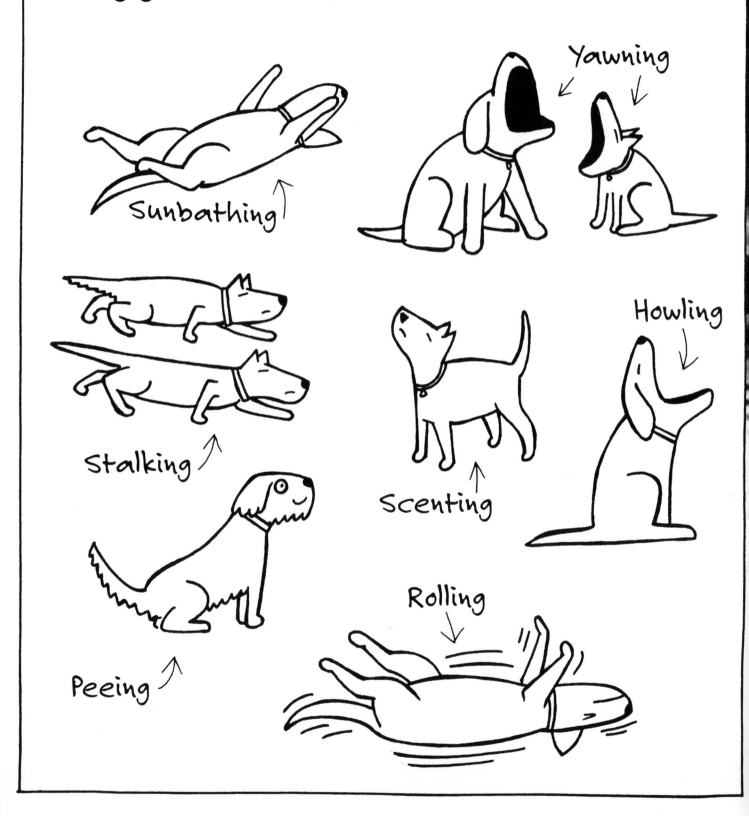

DOODLES

Doggy behaviours...

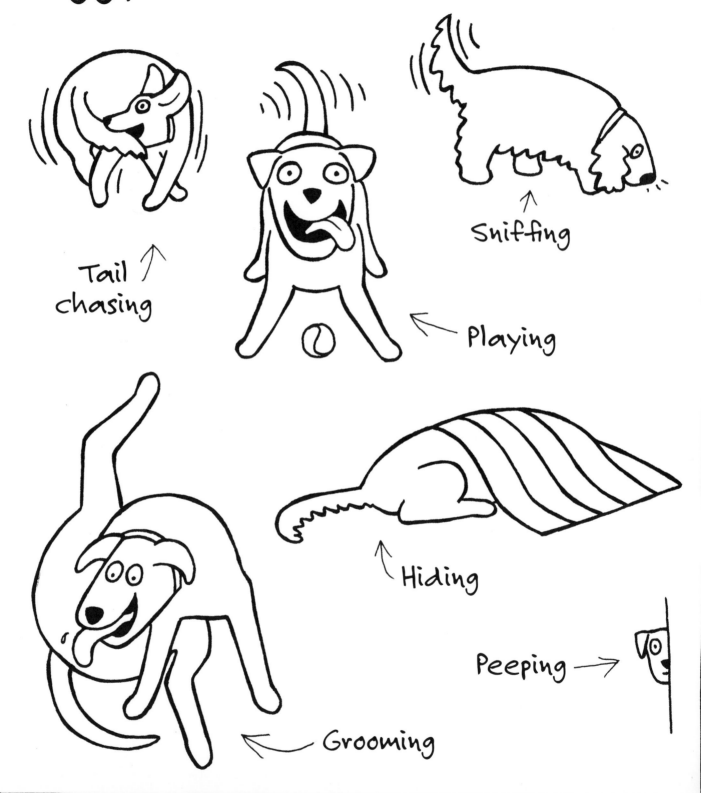

Tail chasing

Sniffing

Playing

Hiding

Peeping →

Grooming

DOODLES

Doggy behaviours...

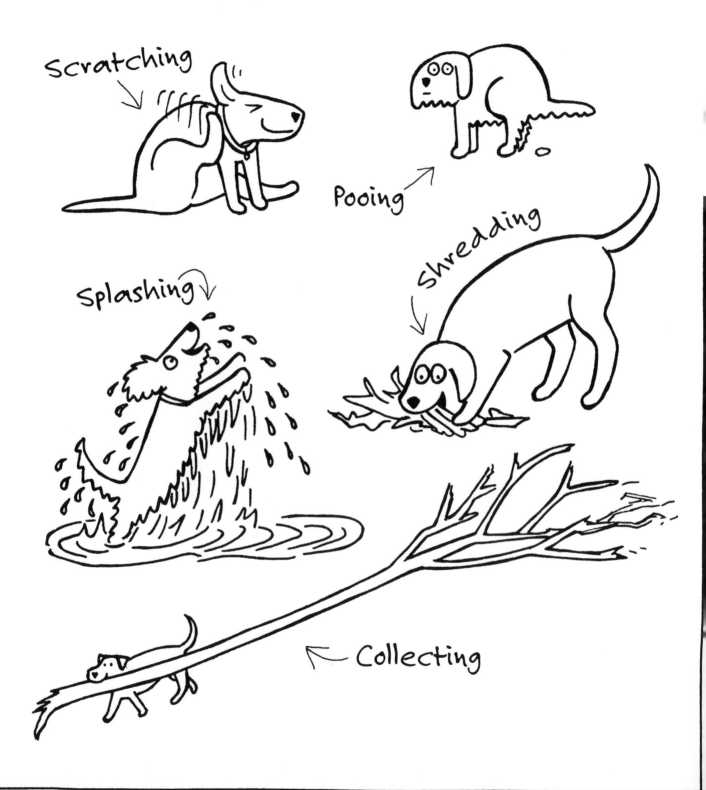

DOODLES

Doggy behaviours...

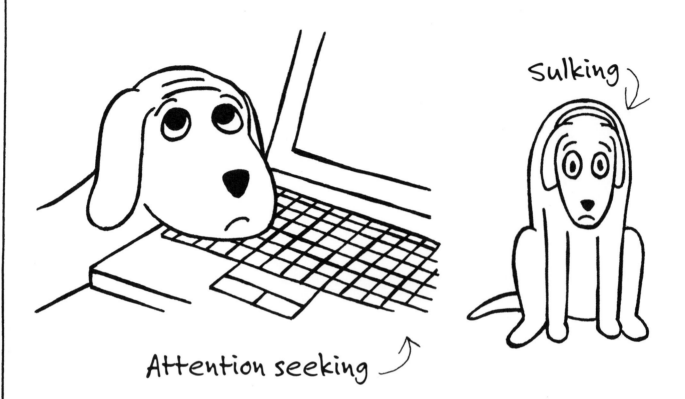

Sulking

Attention seeking

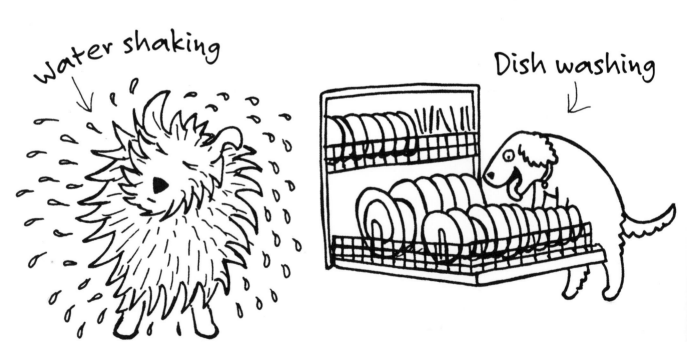

Water shaking

Dish washing

DOGGY DOODLES

Doggy behaviours...

Toy shaking

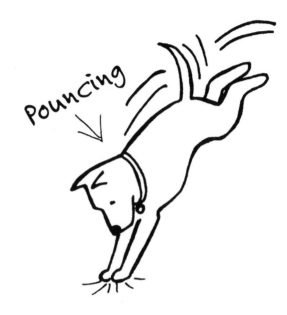

Pouncing

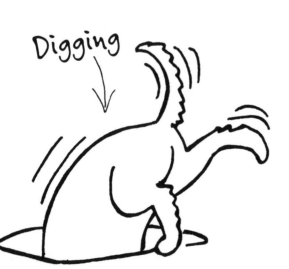

Digging

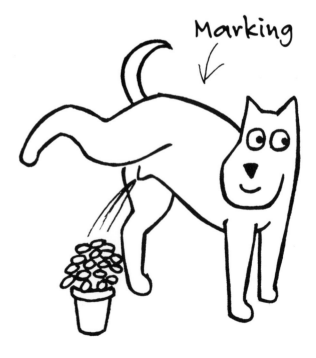

Marking

DOGGY DOODLES

THIS LAZY DOG NEEDS LOUD BARKING DOGS TO WAKE HIM UP

DRAW your loud barking dogs...

THIS DOG IS FEELING SAD BECAUSE HE'S GOT NO FRIENDS TO PLAY WITH

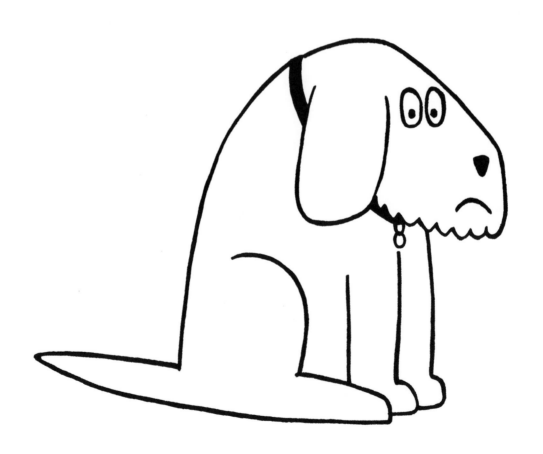

DRAW some HAPPY, PLAYFUL dogs
to play with him and cheer him up...

THIS DOG IS SAD BECAUSE SHE LOST HER FAVOURITE TOY

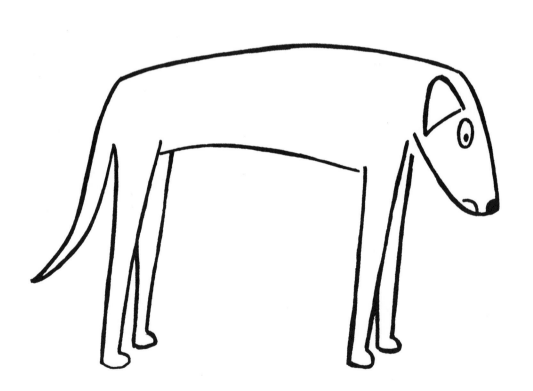

DRAW some FUNNY, WEIRD,
HAPPY dogs to cheer her up...

DOODLES

DOODLES